T0083628

KOLOMAN MOSER

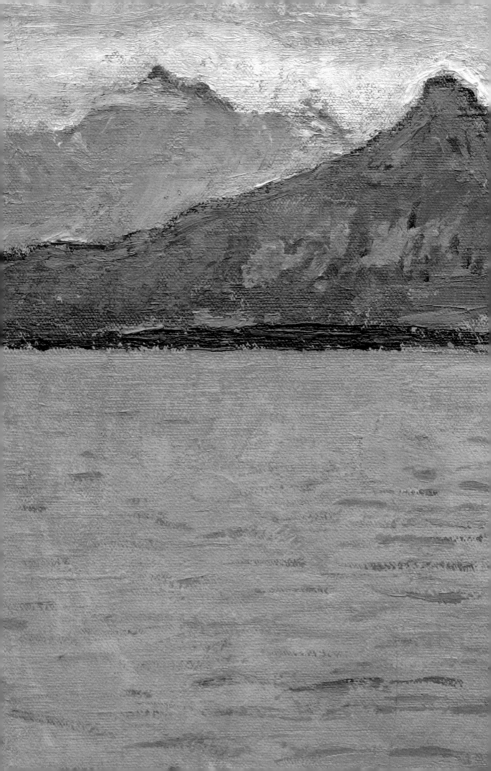

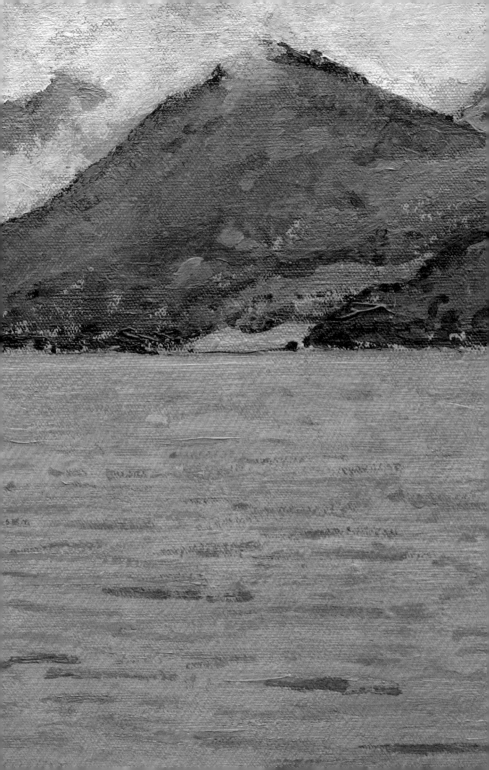

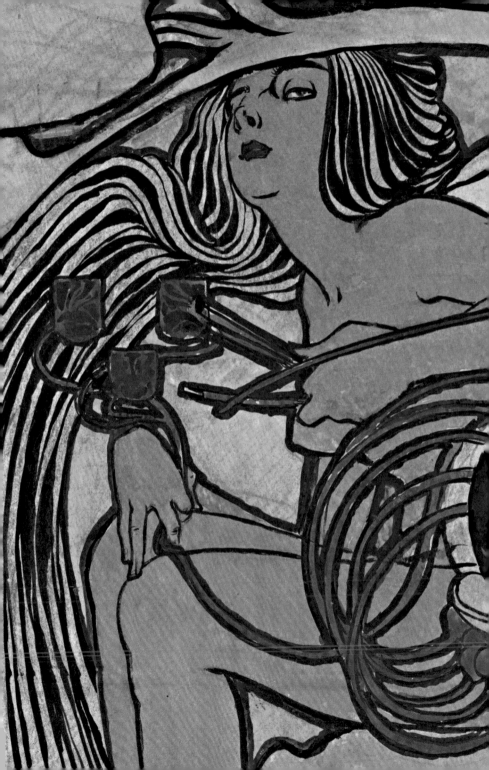

KOLOMAN
MOSER

The Leopold Collection

Elisabeth Leopold
Stefan Kutzenberger

HIRMER

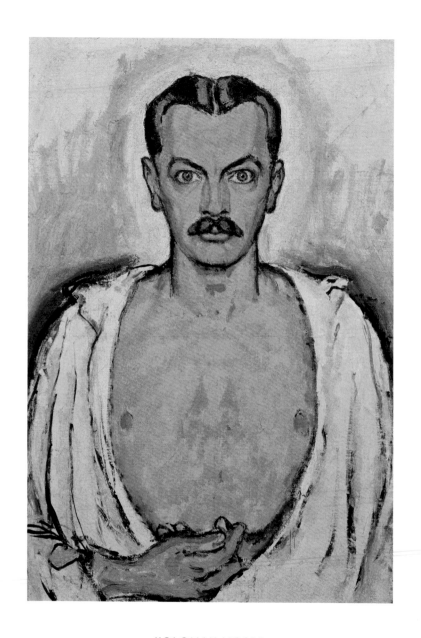

KOLOMAN MOSER
Self-Portrait, c. 1916, oil on canvas
74×50 cm, Belvedere, Vienna, inv. no. 5569

CONTENTS

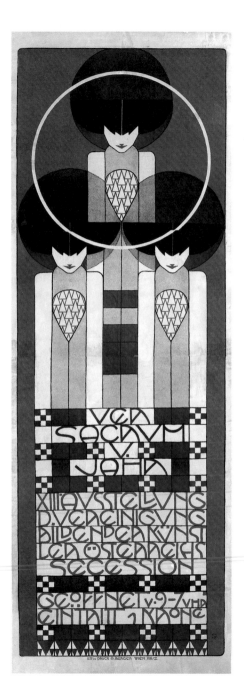

KOLOMAN MOSER, "THE THOUSAND-ARTIST"

Elisabeth Leopold
Stefan Kutzenberger

FINALE AND PRELUDE

Koloman Moser – who called himself "Kolo Moser" – is so closely associ-
ated with the phenomenon "Vienna around 1900" that his diverse body of
work can only be understood in the context of the cultural-historical up-
heaval of that period. The art writer Otto Breicha fittingly called the
cultural transformations before and after 1900 "Finale und Auftakt"
(Finale and Prelude). The finale of the prevailing convention was certainly
dazzling, as wonderfully evidenced by the excessive splendour of the
paintings by Hans Makart and the grand Revivalist buildings of the Ring-
strasse. The latter impressed the great art historian Sir Ernst Gombrich,
who lived in Vienna as a child, so much in their architectural diversity that
he decided to dedicate his life to art.

However, an air of decadence and transience was already blowing over this
lavish grandiosity. Just as the idea of death suddenly became a part of com-
poser Franz Schubert's music a century earlier, so the art of the fin de
siècle also contained a hint of the decline that was to become a fact with

I *Poster for the 13th Exhibition of the Vienna Secession*, 1902
Colour lithograph on paper, 183.5 × 63.3 cm, Leopold Private Collection

the First World War at the latest. However, alongside this finale there was also a "prelude" – the prelude to the modern world that we still live in today.

In retrospect the years before the First World War are often portrayed as the calm before the storm. Contrary to this cliché, Austria experienced at that time a vital phase during which life underwent a revolutionary transformation in all areas. Sigmund Freud explored the subconscious through his dream interpretations, women began the process of emancipation, music grew beyond the foundations of harmony and painting liberated itself from the now outdated Historicism and brought about an individual form of modernity. While Gustav Klimt was certainly the central figure of Viennese Art Nouveau, Kolo Moser was undoubtedly the most versatile.

In all areas, Vienna suddenly produced leading individuals whose work is still admired around the world. Stefan Zweig, Arthur Schnitzler and Hugo von Hofmannsthal were just some of the rich literary talents of that time; Gustav Mahler and a short while after him Arnold Schoenberg and his circle are representatives from the field of music. Otto Wagner, Josef Hoffmann, Joseph Maria Olbrich and Adolf Loos made a great developmental leap in architecture, while Moritz Schlick and Ludwig Wittgenstein among many others created a name for themselves in the field of philosophy. Austrians now became leaders in the fields of the exact sciences such as physics (Ernst Mach and Ludwig Boltzmann), of law (Hans Kelsen and Anton Menger) and of economics (Eugen von Böhm-Bawerk, Friedrich von Hayek and Joseph Schumpeter). It still is not fully explained why the Vienna of around 1900 was able to become this creative centre of Europe. However, significant factors – alongside the institution of the coffee house where people would meet and engage in lively debate – were the active communication of art, literature and science.

By formally incorporating the surrounding villages the foundation was laid for Vienna to grow in population as well as culturally and creatively. The Ringstrasse does not just connect the former suburbs with the city centre; its unique mix of aristocratic prestige buildings, private villas and civic institutions also demonstrates that social boundaries were overcome in this girdle around Vienna's centre. The co-existence of public and private buildings is still a fascinating aspect of this curving grand boulevard. Its sometimes adventurous-looking architectural variety demonstrated a remarkable sequence of widely different styles of previous eras. At times it

overwhelmed art historians in their desire for classification to such an extent that they simply invented the term "Ringstrasse style".

Vienna's population grew fourfold in the fifty years before 1900, from around half a million to more than two million. Migrants came from all the regions and provinces of the "Danube monarchy"; of course there were not just winners but also many losers in all this sudden growth. Vienna acquired not only its unique Ringstrasse and its magnificent mansions; at the same time it also gave rise to warren-like slums – all in a city in which you could "travel a hundred years in a day", as Robert Musil mused after World War I retrospectively and somewhat nostalgically about Vienna.

KOLO MOSER AND THE "GESAMTKUNSTWERK"

In 1897 a group of progressive artists, Kolo Moser among them, established the "Union of Austrian Artists, Secession" under Gustav Klimt's leadership. The artists of the Secession called their periodically published magazine *Ver Sacrum* (Sacred Spring). In contrast to a past of traditional beauty (schöner Schein) was built a world of "naked truth", the title chosen by Gustav Klimt for a large painting that depicts a naked woman holding a mirror up to the viewer.

Kolo Moser was the ideal master for the creation of the Gesamtkunstwerk that was "Vienna around 1900". It was for good reason that the great art critic of the turn of the century, Hermann Bahr, called him a "Tausendkünstler", "Thousand-Artist", because it was true: he had virtually no equal when it came to versatility and productivity. Drawing on an unending wealth of imagination, Moser worked with the different materials with incredible virtuosity. He personally explained his creative gift by stating that as the son of the property manager of the Theresianum grammar school in Vienna he had had access to all the workshops and had been able to watch the craftsmen at work from a young age. His great talent did not go undiscovered for long and his father finally supported his son's artistic career.

When Kolo Moser was accepted into the Academy of Fine Arts as an 18-year-old in 1886, nobody knew yet that he would have a leading impact on shaping the art of Viennese Modernism. Kolo Moser's father died much too soon in 1888, which is why he had to pay for his own studies and started producing illustrations for Austrian and German art magazines. This was a seminal experience for him and one through which he quickly won connections in the art world throughout the entire German-speaking region. His designs hit the fashion of the day completely, but already demonstrated that he had taste and imagination and beyond that also an exceptional sense of how to divide up areas and balance black and white. The *Butterfly Girl* he created a little later for the magazine *Ver Sacrum* (see p. 71) is in this tradition.

He met Gustav Klimt in 1895 while working on his contribution to the portfolio *Gerlach's Allegories*. During this time he also became a member of the Siebener-Club (Club of Seven) in which the young architects around Otto Wagner (Josef Hoffmann, Joseph Maria Olbrich, Josef Urban) and fellow painters (such as Leo Kainradl and Max Kurzweil) met up for debate and inspiration. This group was one of the germ cells that led to the founding of the Vienna Secession. In May 1897 Kolo Moser, along with Gustav Klimt and other kindred spirits, left the conservative Künstlerhaus and quickly became one of the leading figures in the Vienna Secession he helped found – a movement for which he also designed the letterhead and signet (2).

When the first general meeting of the Secession decided they should publish their own magazine, Moser is likely to have been substantially involved in the idea. As the driving force he oversaw the study group and created almost 140 contributions for *Ver Sacrum* (see also the chapter "Archive", p. 68ff) in just six years. It was the goal of the publishers to disseminate the artists' efforts far and wide and it was Moser's graphic art that literally managed to find its way into every last corner of Austria-Hungary over time. Thanks to his special talent for typography and commercial art, banknotes and postage stamps (3) in the Habsburg empire were also based on his designs.

In those years, however, Moser was above all the driving force that shaped the Secession. In addition to designing *Ver Sacrum* he also created

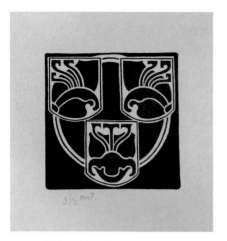 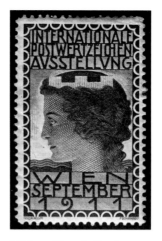

2 *Design for the emblem of the "Vereinigung bildender Künstler Österreichs, Secession"*, 1897, pencil, Indian ink on card, 26.7 × 28.5 cm, Leopold Museum, Vienna inv. no. 2679

3 Koloman Moser, Ferdinand Schirnböck, *Publicity Stamp for Postage-Stamp Exhibition*, 1911 Copper engraving, dark green 4.2 × 2.7 cm, Leopold Museum, Vienna, inv. no. 5292

numerous posters, for example for the first Secession exhibition (5), which was however used for the fifth and can be understood as a link between the young and the more mature artist. The sensational *Poster for the 13th Exhibition* (1) depicts three female figures that are actually three candle flames into which three bowed female faces have been incorporated. Another seminal activity in which Moser was involved was the design of the exhibition spaces of the new Secession building that opened in 1898. The art critic Ludwig Hevesi elevated Moser's "atmospheric hanging" to an artwork in its own right. The most important exhibitions Moser designed were probably the eighth, featuring George Minne, the great exhibition on Gustav Klimt's work in 1903, in which Moser also used his *Purkersdorf chair* as a design element, and the Ferdinand Hodler exhibition in the spring of 1904, which was to be an important basis for the later international reputation of the Swiss artist.

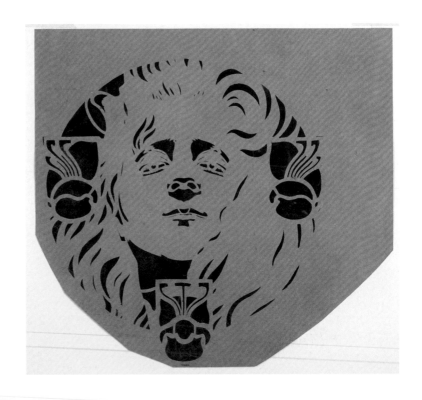

4 *Cover design of the 1st founding portfolio of "Ver Sacrum" with an allegorical head of a woman and the emblem of the Secession,* 1899, stencil print in blue on paper, sheet dimensions: 37.5 × 40 cm, Leopold Museum, Vienna, inv. no. 1652

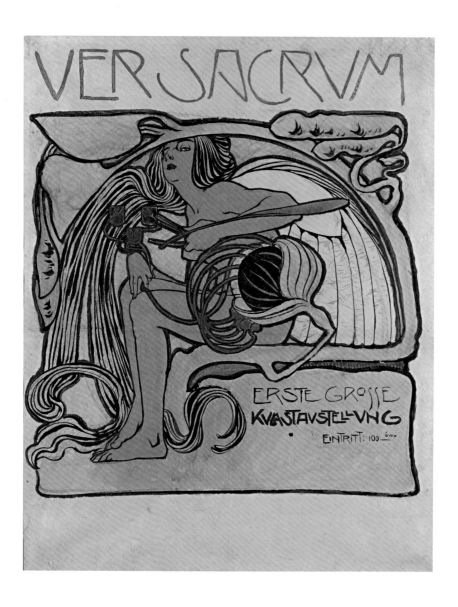

5 *Poster design for the "ERSTE GROSSE KUNSTAUSSTELLUNG" of the Secession*, 1897
Watercolour, gouache, coloured pencil, metallic paints on tracing cloth
79.8 × 61 cm, Leopold Museum, Vienna, inv. no. 1750

6 *"Girl Dancing to the Right". Design drawing for a metal relief*, 1904, pencil, Indian ink on squared paper, 26.2 × 41.3 cm
Leopold Museum, Vienna, inv. no. 1693

7 *"Dancing Girl". Design drawing for a metal relief*, 1904, pencil, Indian ink on squared paper 27.5 × 33 cm
Leopold Museum, Vienna, inv. no. 1692

8 *Fabric design "Blütenerwachen", design no. 3907*, 1900, Indian ink on paper 49.5 × 30.2 cm, Leopold Museum, Vienna inv. no. 6042

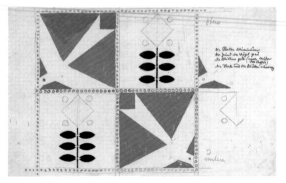

9 *Design for a wall decoration for the bed-room in the Stonborough flat in Berlin*, 1902/03 Pencil, ink, opaque colour on squared paper, 21 × 33.7 cm Leopold Museum, Vienna, inv. no. 2703

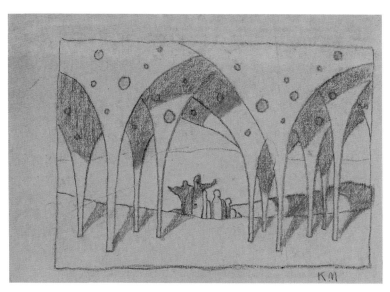

10 *Stage set design for Julius Bittner's opera "Der Bergsee"*, c. 1910
Coloured chalk on paper, 20.5 × 26.5 cm, Leopold Museum, Vienna, inv. no. 2694

11 *Stage set design for Ludvig Holberg's "Jeppe vom Berge", 3rd set: "Morgen"*, c. 1912
Coloured chalk on paper, 27 × 41.3 cm, Leopold Museum, Vienna, inv. no. 2731

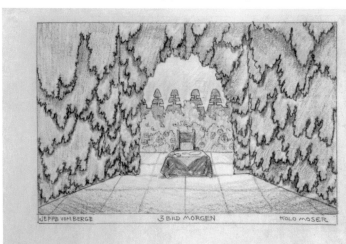

APPLIED ART

Productive and creative as Kolo Moser was in the context of his activities in the Secession, he nevertheless felt an urge to engage in other forms of expression. In 1899 he began teaching at the Kunstgewerbeschule (School of Applied Art) of the Österreichisches Museum für Kunst und Industrie (Imperial Austrian Museum of Art and Industry) in Vienna, where he was made professor of decorative drawing and painting in 1900. He remained there until his death, passing on his visions of Modernism to subsequent generations. He tirelessly designed items of furniture, fabrics, glasses, ceramics and much more for many factories in Vienna, thereby laying the foundation for his activities in the applied arts. If we look at Moser's works, we are regularly surprised by the variety of materials used and by his wealth of ideas. When the corner cabinet is still closed, we can only see the tears of *Die verwunschenen Prinzessinnen* (12, The Enchanted Princesses); they can only be dried when the princesses are freed by opening the cabinet. The desire that all areas of life should be penetrated by art, a desire reaching ever larger segments of the population, increased the demand for high-quality arts and crafts and finally led to the establishment of the Wiener Werkstätte.

The Austrian Museum for Art and Industry hosted an exhibition of English furniture in 1900 in order to inspire local craftsmen in their sense of form and manufacturing techniques. It was there that Moser saw furniture by the Scottish artist duo Charles Rennie Mackintosh and his wife Margaret MacDonald Mackintosh – two members of the British Arts & Crafts movement. The chairs with high backs in particular became an important source of inspiration for his high armrest chair for Prag-Rudniker (13). That same year the British artists became involved in the eighth exhibition of the Vienna Secession and influenced not just Kolo Moser but also Josef Hoffmann and Joseph Maria Olbrich, who as a result also learned about the many international reform movements.

Together with Josef Hoffmann and the industrialist Fritz Waerndorfer, Moser set up the Wiener Werkstätte as a "production co-operative of craftsmen in Vienna" in May 1903. By maintaining close collaboration between the designing artist and the executing craftsman a completely new level of quality in arts and crafts could be achieved. As the first major commission Kolo Moser designed the home interior for Hans Eisler von

Terramare. The inlaid cupboard (19) from the bedroom is particularly significant. Moser implemented several interiors for the Wiener Werkstätte that were to make history as Gesamtkunstwerke of Viennese Modernism. However, he also designed furniture, jewellery, glasses, fabrics, toys, book covers and other everyday items. After just four years, in 1907, the individuals involved went their separate ways again because of commercial differences, whereupon Kolo Moser started focusing more on painting again.

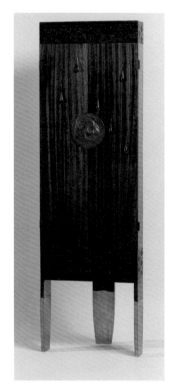 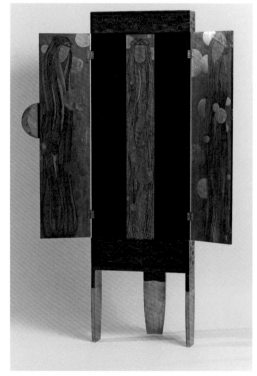

12 Koloman Moser, Portois & Fix, *Corner cabinet "The Enchanted Princesses"*, 1900
Padauk wood, copper-plated, white metal, glass, 171 × 53 × 33 cm, Private collection

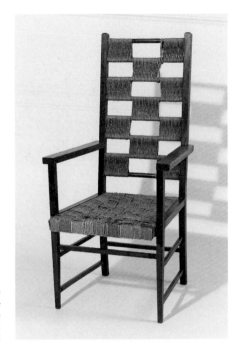

13 Koloman Moser
Prag-Rudniker, *High-backed chair*
1903, wood, raffia weave
122.5 × 58.8 cm
Leopold Private Collection

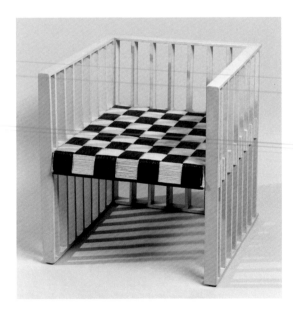

14 Koloman Moser
Prag-Rudniker, *Armchair,
used in the 18th Secession
exhibition and in the
lobby of the Purkersdorf
Sanatorium*, 1903
Beechwood, lacquered
basketwork
72.5 × 65.8 × 66.5 cm
Leopold Museum,
Vienna, inv. no. 4354

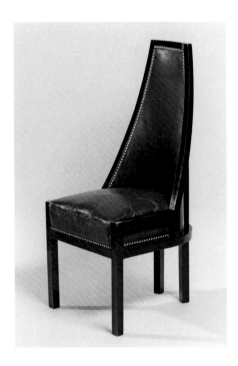

15 Koloman Moser, Jacob & Josef Kohn Factory
High-backed chair in black with blue leather
c. 1901, wood, lacquered in black, leather
113.5 × 50 × 53 cm, Leopold Museum, Vienna
inv. no. 4445

16 Koloman Moser, Wiener Werkstätte
Bench from the Hellmann salon interior
1904, maple lacquered black, velvet
cover not original, 89.8 × 185.2 × 82 cm
Leopold Museum, Vienna, inv. no. 4539

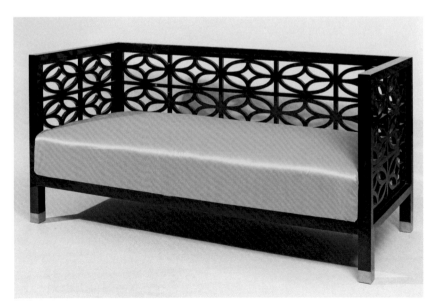

17 Koloman Moser, *Advertisement for the furniture company Jacob & Josef Kohn*, c. 1904
Colour lithograph, gold print on paper, 33.4 × 33.4 cm, Leopold Museum, Vienna, inv. no. 1658

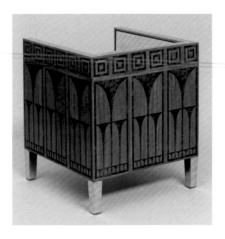

18 Koloman Moser, Caspar Hrazdil
(execution), *Chair from the breakfast
room in the flat belonging to Eisler von
Terramare* 1903, thuja, satinwood veneer
Metal feet 70.3 × 59.5 × 59.8 cm
Leopold Museum, Vienna, inv. no. 6083

19 Koloman Moser, Caspar Hrazdil
(execution), *Inlaid cupboard from the
bedroom in the Eisler von Terramare flat*,
1903, maple, marquetry of different woods
Ivory, mother of pearl, 210 × 130 × 60 cm
Leopold Museum, Vienna, inv. no. 4150

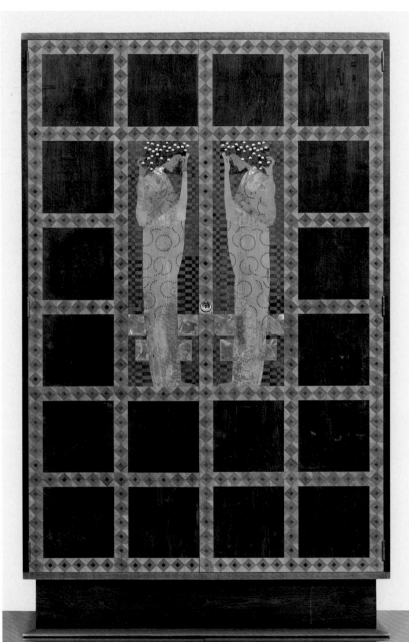

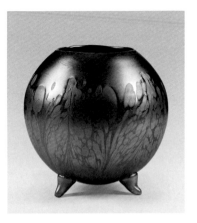

20 Koloman Moser, Joh. Lötz Witwe
Vase with a lustre finish, c. 1900, glass, opal glass
base and different fused applications
18.4 × 20.5 × 20.5 cm, Leopold Museum, Vienna
inv. no. 4305

21 Koloman Moser, Joh. Lötz Witwe
*Vase with a lustre finish in a spherical shape with
three feet, décor "Phänomen Gré"*, c. 1900
24.5 × 12.5 cm, Leopold Museum, Vienna
inv. no. 4244

22 Koloman Moser, Meyr's Neffe for E. Bakalowits & Söhne, *Pieces from the tableware set
"Meteor" no. 100*, 1899, glass (colourless), Leopold Private Collection

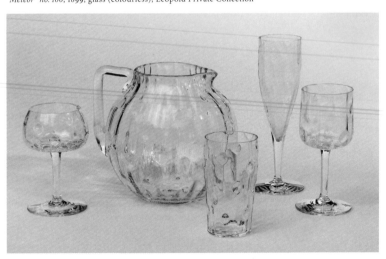

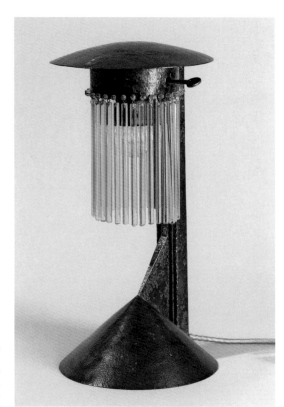

23 Koloman Moser
Wiener Werkstätte (Karl Medl)
*Lamp with glass rods from the Flöge
sisters' salon*, 1904, silver-plated
alpacca, glass, 37.5 × 18.5 × 18.5 cm
Leopold Private Collection

24 Koloman Moser, Leopold Bauer, *Two cube-shaped vases with blue décor "Zephyr"*
1900, glass, 14 × 14 × 14 cm, Leopold Museum, Vienna, inv. no. 4257

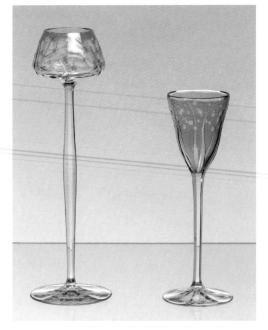

25 Koloman Moser, Meyr's Neffe for E. Bakalowits & Söhne, *Four glasses from the tableware set "Meteor" no. 100* (lime green, red, yellow, dark green), 1899, glass, 20.1 × 7.5 × 7.5 cm
Leopold Museum, Vienna, inv. no. 4458

26 Koloman Moser
Meyr's Neffe for E. Bakalowits
& Söhne, *Tall stemmed glass
and stemmed glass*, 1900
glass (amber yellow, pink)
30 × 9.2 cm, 23 × 8.2 cm Leopold
Private Collection

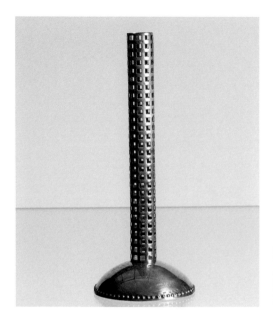

27 Koloman Moser
Wiener Werkstätte
Lattice vase, 1904
Silver, 21.5 × 8.6 cm
Leopold Museum,
Vienna, inv. no. 4558

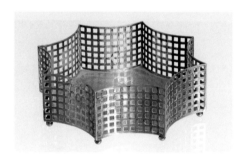

28 Koloman Moser,
Wiener Werkstätte
Small fruit basket, 1904
Silver, 5.4 × 16.4 × 16.4 cm
Leopold Museum, Vienna, inv. no. 6090

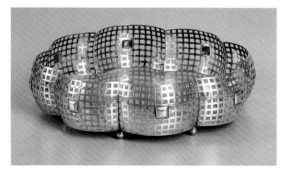

29 Koloman Moser, Wiener
Werkstätte, *Bread basket*, 1905/06
Silver, 6.6 × 25 × 25 cm, Leopold
Museum, Vienna, inv. no. 6091

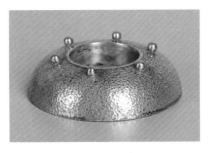

30 Koloman Moser, Wiener Werkstätte
Sponge bowl, 1903, copper (silver-plated)
4 × 12.6 × 12.6 cm, Leopold Museum, Vienna
inv. no. 6092

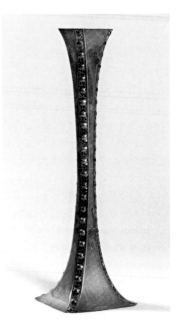

31 Koloman Moser, Wiener Werkstätte
Slender vase, model no. M 1619, around 1908
Brass, silver-plated, 42.8 × 13 × 13 cm
Leopold Museum, Vienna, inv. no. 4542

32 Koloman Moser, Wiener Werkstätte (Alfred Mayer), *Fruit platter*, 1904
Silver, lapis lazuli, ivory, 25.5 × 25.5 × 15 cm, Leopold Museum, Vienna, inv. no. 6093

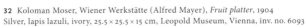

On 1 June 1905 Kolo Moser married Editha (Ditha) Mautner von Markhof. During this period of his life his personal happiness and professional difficulties were intertwined: the most important official commission in Vienna for the all-round talent was providing the Church of St Leopold with glass windows and mosaics. By using the technique developed for glass mosaics as well as reflective gold and opalescent glass, he succeeded in creating a particularly picturesque effect for the windows. His commission for the church became increasingly difficult since his ideas for the figures – particularly the angels' heads – were seen as too fashionable and unworthy of being in a church. When Kolo Moser then converted to Protestantism because of his wedding the scandal was complete and the commission was taken away from him. Only his window designs (36) were put into effect. His successor sued him for defamation since Moser had repeatedly made accusations of plagiarism.

After his separation from the Wiener Werkstätte Kolo Moser started focusing more on painting again, just as he had done in the early days of his career. His 1907 painting *View of the Rax* was among the landscape motifs Moser preferred to paint during that time. He often sought inspiration from the surrounding mountain backdrop in the summer residence belonging to his wife's family near the Semmering Pass. It was his goal to have the viewer's gaze take a walk through the picture. Following on from his early works, Moser painted realistic pictures of nature. He described every branch, every ray of sunlight and every shadow in detail, trying to make the qualities of the different surfaces tangible. Kolo Moser allowed himself a new beginning. The accurate representation of colours and motifs felt like a break with the Secessionist phase, before his attention was drawn to the insights of colour theory and he found a new form of expression.

Between 1907 and 1916 he produced portraits and landscapes in new, attractive coloration, such as *Lake Wolfgang with High Horizon* (42), *Bergketten – Blue Twilight* (46) and *Venus in the Grotto* (49) as well as many allegorical and mythological depictions including *Wotan and Brünhilde* (54). The bold colourfulness and the way it is used to create strong contrasts are based on Moser's intensive confrontation with avant-garde theories of colour and perception. During a trip to Switzerland he visited

Ferdinand Hodler (1853–1918), whom he had known from his earlier years; he subsequently incorporated much from this artist into his own work. Rudolf Leopold talks about this in the following interview, p. 33ff.

DR ELISABETH LEOPOLD *was born in Vienna. She studied medicine and worked as an ophthalmologist until 1994. She met Rudolf Leopold at university and soon shared his passion for the visual arts. By 1950 they were already discovering and collecting the works of Egon Schiele, a forgotten artist at the time. In the following years they expanded their art collection with outstanding masterpieces, especially those by artists of the Secession, such as Gustav Klimt, Kolo Moser and other remarkable Austrian artists. This treasure was the starting point for the Leopold Museum in Vienna's Museum Quarter. Elisabeth Leopold is a lifetime board member, the curator of many exhibitions and the author of many articles about art and culture in Vienna around 1900.*

DR STEFAN KUTZENBERGER *studied comparative literature in Vienna, Buenos Aires, Lisbon and London. Born in Linz, he now works as a curator, art educator and librarian in the Leopold Museum, Vienna, and as a lecturer at the University of Vienna. He is also a founding member of the working circle of the Austrian research group "Wissenschaft und Kunst" ("Science and Art"). He is the author of several publications on the visualisation of literature, on intermediality in Vienna around 1900 and on the literary interplay between European and Latin American literature.*

THE KOLO MOSER PHENOMENON – RUDOLF LEOPOLD IN CONVERSATION

The sensitive and enthusiastic art collector and museum founder Rudolf Leopold found the very best words to describe Kolo Moser's diverse and extensive artistic work, so that we are including here excerpts from an interview that the art historian Gerd Pichler conducted with him in 2007.

Gerd Pichler: What fascinates you about Koloman Moser's artistic work?

Rudolf Leopold: The thing that fascinates me about Kolo Moser's artistic personality is his incredibly diverse range coupled with the high quality of his work in every area. After some decorative designs for magazines in the early days, such as the *Meggendorfer Blätter*, and for *Gerlach's Allegories*, Moser found himself with a remarkably wide sphere of activity when the Vienna Secession launched its publication *Vers Sacrum* in 1897. At the same time he created posters for the exhibitions of the Vienna Secession, along with pieces of furniture, glasses and all kinds of ceramics and also preparatory drawings for architectural ornaments on Olbrich's Secession Building (such as the three owls, and also the wreath-bearers on the side wall that unfortunately do not exist any more). Because of the large number of decorative designs I'll limit myself here to listing two particularly

impressive ones: Moser's tailpiece for George Minne (33) (reproduced in *Ver Sacrum* 1901 and also on the cover of that same year) and the coloured woodcut *Three Standing Women* from 1902. At Otto Wagner's behest Moser designed the windows for the entrance and side walls of the Church of St Leopold in 1904/05 and in addition to that he designed the large altarpiece. But only the windows were executed.

Gerd Pichler: One of the magnificent pieces of furniture in your Moser collection is the chair for the Purkersdorf Sanatorium (14), which is one of the iconic works of Viennese Modernism.

Rudolf Leopold: Moser was an absolute genius in the way he contrasted the vertical slats lacquered completely in white with a canework seat in a pattern of black-and-white squares. There were several examples of this armchair which were intended for the Purkersdorf Sanatorium built by Hoffmann. But it was also part of Moser's interior design for the exhibition of Klimt paintings in the Vienna Secession building. The following circumstance regarding the objects designed by Hoffmann and Moser for the Wiener Werkstätte seems interesting to me: even though both artists had had a different training background – or maybe because of that – their collaboration for the Wiener Werkstätte worked splendidly. Hoffmann, an architect, and Moser, an artist originally trained as a painter but one with an enormous decorative talent, helped Viennese applied arts to achieve international significance, even world fame.

Moser studied drawing and painting at the Academy of Fine Arts between 1886 and 1892 before switching to the Applied Arts School in 1893, where he completed his education in 1895. While he was still at this latter institution, Moser, as already mentioned, produced contributions for the *Gerlach's Allegories* portfolio and met Gustav Klimt at that time – which also had a certain influence on the development of his painting. In 1899 Moser was appointed a temporary teacher at the Applied Arts School, then one year later he was made professor for the "Decorative Drawing and Painting" class, a job he continued to do until he died in 1918. Then there were countless years during which Moser did not find the time to paint. He was fully occupied with his designs for magazines (of which *Ver Sacrum* is the most important), with exhibition posters and from 1903 in the Wiener Werkstätte with all kinds of arts-and-crafts objects; in fact we have to say

33 Koloman Moser, *Tailpiece for
"Ver Sacrum" special edition on
George Minne*, 1901, printed in:
Ver Sacrum 4, 1901, p. 41

he was overly busy so that he had to neglect his painting during these
years. That changed in 1907 when he left the Wiener Werkstätte. As with
his earlier decorative designs, there is a compositional approach bound up
with flat areas that cannot be overlooked. In contrast to his academic
beginnings his portraits in 1910 were strictly *en face* or in profile. But
otherwise these likenesses are still largely naturalistic.

In 1913 he visited one of his sons in a sanatorium in Switzerland and sub-
sequently went to see Ferdinand Hodler. He had got to know his early
work in 1904, when he created the interior design for the personal exhibi-
tion of this artist in the Vienna Secession – a show that helped Hodler
achieve his international breakthrough. But it was only in 1913, when he
studied Hodler's works in Geneva, that they influenced him to a greater or
lesser extent. Even though Moser did not agree with Hodler's concept of
parallelism – nor the artist's lecturing on the topic – and even though –
rightfully so in my view – he did not really like the colours in Hodler's
Symbolist pictures, he was impressed with the intensity of the contours
and the graphic order of these works. That is how Moser himself described
it in his notebook. The symmetrical construction of the composition in
Hodler's work – not just in his figural works but often also in his landscapes
– also had an impact on Moser, in particular on his figural depictions. In
his landscapes Moser hardly followed Hodler's often overly decorative

manner; Hodler would complete his landscape paintings by having corresponding curved sections at the top and bottom edges, for which he used landscape components or also deformed cloud sections. Hodler made his paintings of mountains equally decorative, where the mountains in reverse symmetry are reflected perfectly in the lakes in the foreground. As a counter-example I want to introduce Moser's picture *Mountain Ranges* from 1913 (46), which might at first glance seem purely decorative. This splendid work was less the result of decorative considerations and more

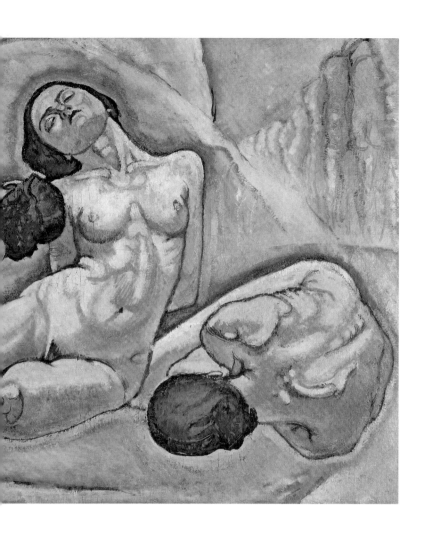

34 *Three Squatting Women*, c. 1914
oil on canvas, 99.5 × 150 cm
mumok – museum moderner kunst
stiftung ludwig wien, Vienna, inv. no. B 133 B

the outcome of compositional ideas. By using shapes and colours the artist managed to give the mountain range a silhouette-like appearance through which the work achieves great expression. Other landscapes by Moser dating from the same period, such as *Lake Wolfgang* once with a high and once with a low horizon (42, 43) or *Semmering Landscape* (45) and *Mountain Peak with Coloured Clouds* also have nothing to do with Hodler's ornamental approach.

In contrast, in his work *Three Squatting Women* (34) (c. 1914) Moser achieved a visual coherence that is convincing not just from a formal perspective but also from a pictorial one; the same is true for *Venus in the Grotto* (49) and its pair, *Wanderer* (50), which in contrast to the previous work does not feature such an intrusive use of blue within the main body of the painting. It must also be mentioned that Moser, unlike Hodler, understood how to force the deliberately unnatural colours into an interesting harmony in many of his late Symbolist paintings. In addition to that he often gave different sections of his pictures, such as for example the figures as compared to the landscape surroundings, a different structure, enriching the pictorial aspect; the version of *Wanderer* that Moser designed to be the pair to *Venus in the Grotto* is a good example of this (it is by no means a study like the last version of *Wanderer;* it is an early version). The fact that Moser referred to most of his pictures as studies only demonstrates that he always felt "on the way" to developing his painting.

Even in pure landscapes Moser had achievements both in the formal and the pictorial aspects so that we can refute the earlier opinion – which Moser, feeling pessimistic about his incurable cancer, shared – that he was unable to reach his goal. I think it is important to note that Moser broke new artistic ground in many of his post-1913 works, both figural works and landscapes, in the bold way in which he used colour.

One of Moser's last paintings – if not the last – is the interesting *Self-Portrait* of 1916 (p. 8), which shows him directly from the front and in which he presents his bare chest framed by an open white shirt. As was the case for Hodler's self-portrait of 1900, Albrecht Dürer's self-portrait of 1500, in which the artist presented himself as Christ, served as a source of inspiration. However, in contrast to Dürer, Hodler left out the hands in the lower portion of the picture. Moser followed Dürer's example with the similarity extending all the way to the position of the thumb and the index finger. This too shows that Moser, just like Dürer, did not do this to draw

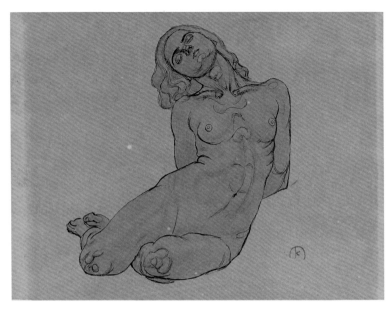

35 *"Seated Female Nude". Study for the painting "Three Squatting Women"*, c. 1914, ink, coloured pencil on tracing cloth, mounted on board, 21.1 × 28.4 cm, Leopold Museum, Vienna, inv. no. 2686

attention to his "sick body", as art historians assume from time to time; instead he, like Dürer, wanted to round off the composition in the lower part of the painting.

Gerd Pichler: Do you have favourite items in your collection of works by Kolo Moser?

Rudolf Leopold: I have many favourite pieces, for example the armchair for the Purkersdorf Sanatorium I already mentioned, the tall bentwood cupboard (from the Jacob & Josef Kohn workshop, 1901), a brilliantly constructed table lamp with pendant glass rods (23) and the poster for the 13th exhibition of 1902 (1); then there are several paintings, such as *Semmering Landscape* (45) with a fascinating play with sunrise or sunset colours, *Mountain Ranges* (46) and *Mountain Peak with Coloured Clouds* (all 1913), the versions of *Venus in the Grotto* and *Wanderer* (both 1914; 49, 50), and then *Wotan and Brünhilde* (54) with the electrifying use of pink and ultramarine together (c. 1916) and finally the large-format composition

Tristan and Isolde (52) (c. 1915) for which Moser specially designed a well-suited frame.

Gerd Pichler: In your opinion, is Koloman Moser's significance as a painter and an applied artist honoured equally?

Rudolf Leopold: With the rediscovery of the stylised art of the turn of the century, which only happened at the end of the 1970s, it was recognised that Moser was one of its most important protagonists. His versatility and wealth of invention are almost beyond belief! He took all the items of everyday life and redesigned them in new artistic forms, creating a total work of art: entire interiors, many of them with precious inlaid furniture, tableware, luxury objects such as glasses and vases in all kinds of shapes, wallpaper, curtains and even clothes; and we must not forget Moser's very original designs for postage stamps, of which we should mention in particular his outstanding series for the imperial jubilee in 1908. The fact that Moser is of great significance as a painter was also recognised by Professor Lemoine, the director of the Musée d'Orsay. That is why he exhibited him together with Schiele, Klimt and Kokoschka in the Grand Palais in Paris – much to the surprise of some art historians here. Uninfluenced by this negative judgement I started acquiring pictures by Kolo Moser in the 1960s. I still consider Moser, alongside Klimt and Hoffmann, as the most significant artist of the Vienna Secession. Moser was able to incorporate so much that was new in so many different areas of art; his unique position has been recognised and increasingly honoured for several years now on the international art market.

36 *Design for the Angel Window in Otto Wagner's Church of St Leopold*, 1905
Gouache, black ink on paper, 436.5 × 144 cm, Leopold Museum, Vienna, inv. no. 5270

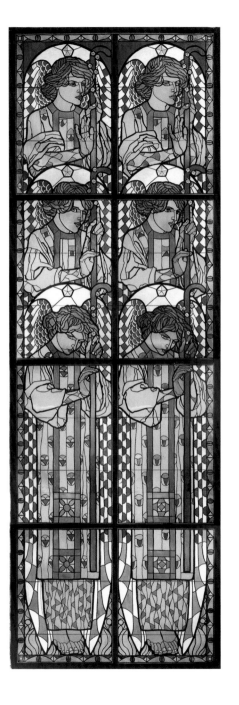

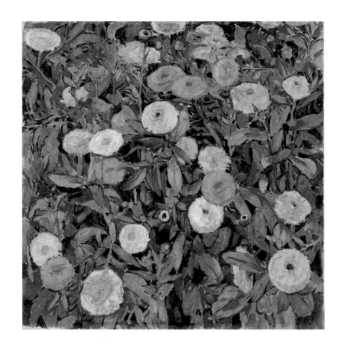

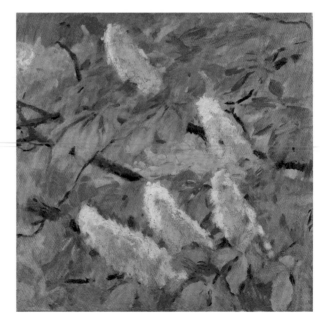

37 *Marigolds*, 1909, oil on canvas, 50.3 × 50.2 cm
Leopold Museum, Vienna, inv. no. 151

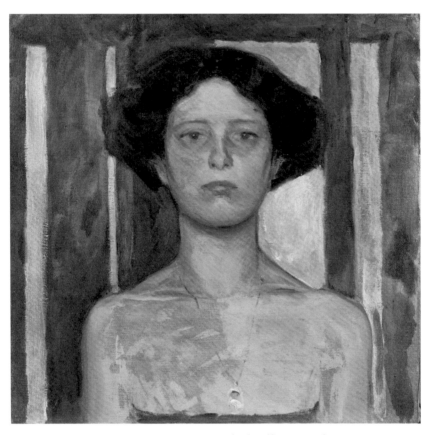

39 *Girl with Necklace*, c. 1910, oil on canvas, 50.6 × 50.4 cm,
Leopold Museum, Vienna, inv. no. 150

38 *Chestnut Blossoms*, c. 1912, oil on canvas, 76 × 75.5 cm
Leopold Museum, Vienna, inv. no. 631

40 *Chestnut Tree in Blossom*, c. 1912, oil on canvas, 100.3 × 100 cm
Leopold Private Collection

41 *Nude Woman from Behind*, c. 1913, oil on canvas, 75 × 50 cm
Leopold Museum, Vienna, inv. no. 581

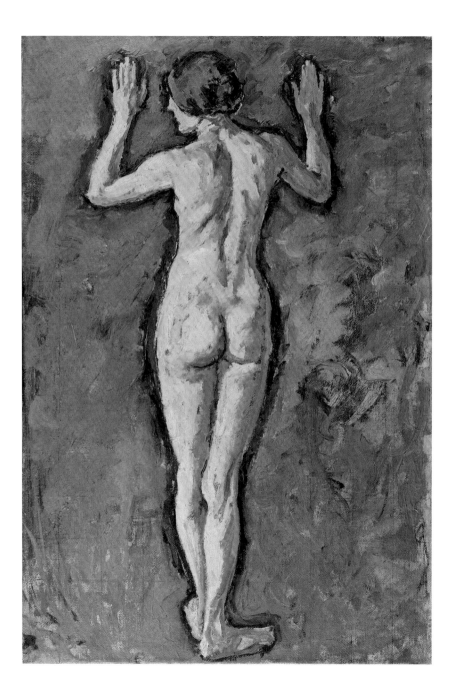

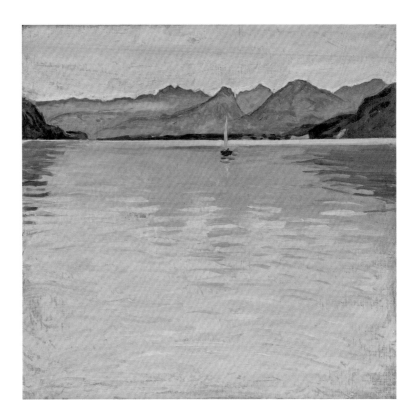

42 *Lake Wolfgang with High Horizon*, c. 1913, oil on canvas, 32.5 × 32.5 cm
Leopold Museum, Vienna, inv. no. 89

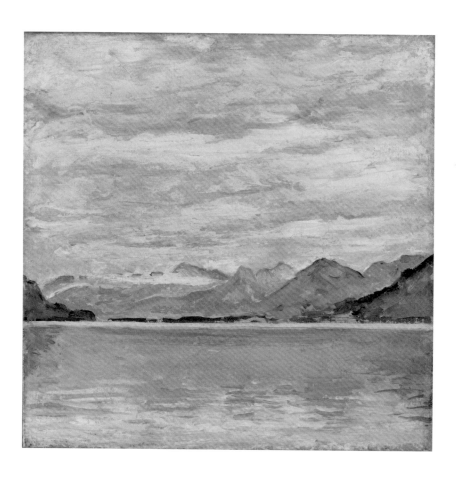

43 *Lake Wolfgang with Low Horizon*, c. 1913, oil on canvas, 32.5 × 32.5 cm
Leopold Museum, Vienna, inv. no. 90

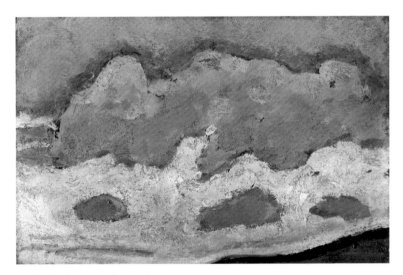

44 *Cloud Study*, c. 1914, oil on board, 20 × 30 cm
Leopold Museum, Vienna, inv. no. 513

46 *Mountain Ranges – Blue Twilight*, 1913, oil on canvas
38 × 50.3 cm, Leopold Museum, Vienna, inv. no. 503

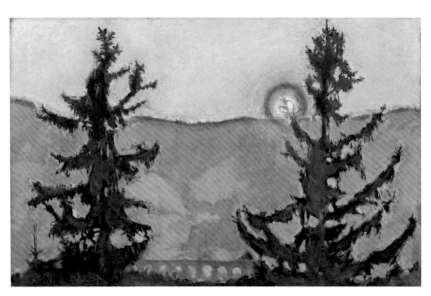

45 *Semmering Landscape at Sunset*, 1913, oil on board, 45.4 × 70.2 cm
Leopold Private Collection

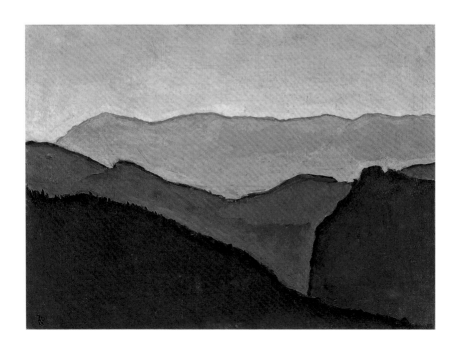

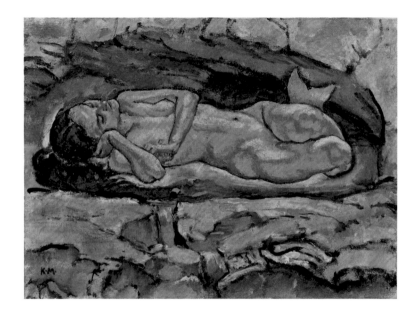

47 *Mermaid*, 1914, oil on canvas, 37.7 × 50.3 cm
Leopold Private Collection

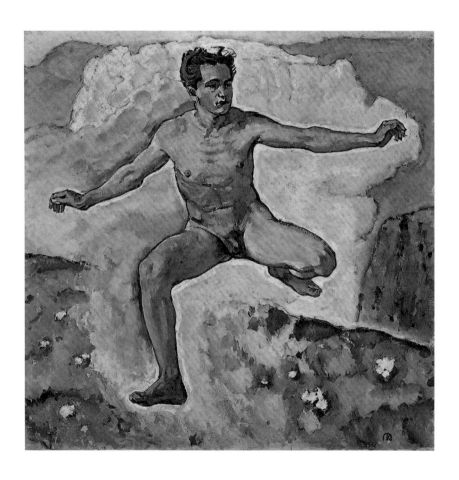

48 *Spring*, c. 1913, oil on canvas, 100 × 100 cm
Leopold Private Collection

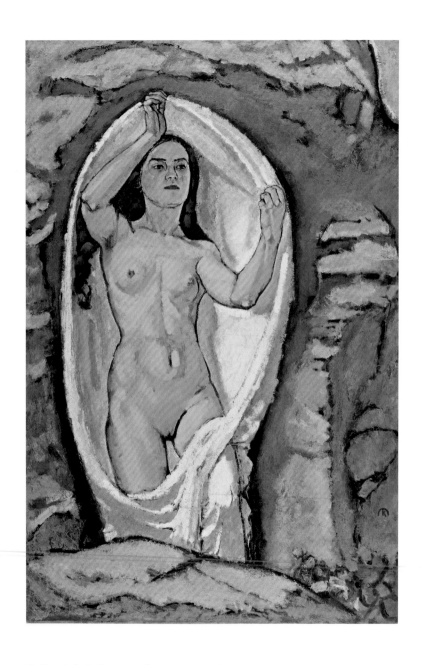

49 *Venus in the Grotto*, c. 1914, oil on canvas, 149.4 × 99 cm
Leopold Museum, Vienna, inv. no. 1999

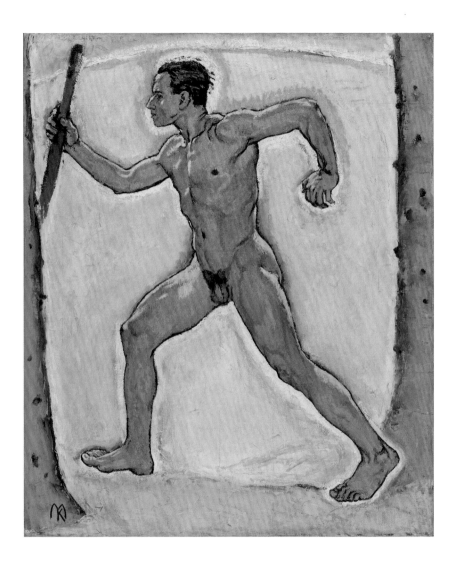

50 *The Wanderer*, c. 1914, oil on canvas, 75.5 × 62.4 cm
Leopold Museum, Vienna, inv. no. 584

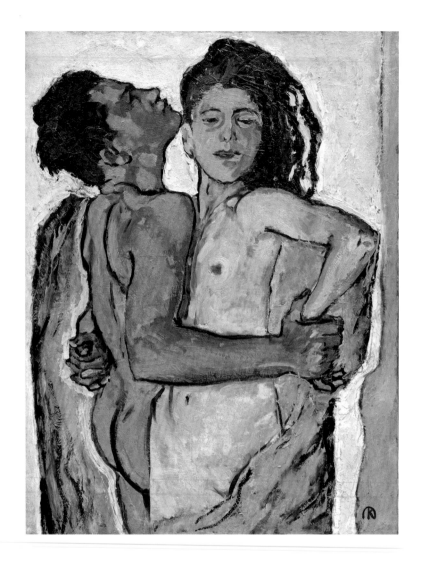

51 *Loving Couple*, c. 1914, oil on canvas, 99.8 × 74.7 cm
Leopold Private Collection

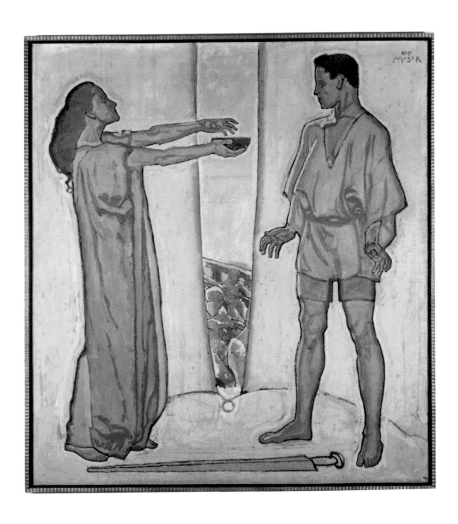

52 *The Love Potion (Tristan and Isolde)*, 1913/1915, oil on canvas
210 × 196 cm, Leopold Private Collection

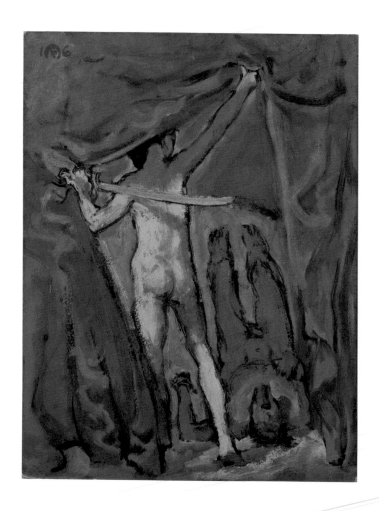

53 *Judith and Holofernes*, 1916, oil on board, 49.5 × 37.9 cm
Leopold Museum, Vienna, inv. no. 578

54 *Wotan and Brünhilde*, c. 1916, oil on canvas, 50.5 × 75.2 cm
Leopold Museum, Vienna, inv. no. 585

55 Kolo Moser, sitting in the studio, c. 1895, Private collection, Vienna

BIOGRAPHY

Koloman Moser
1868 – 1918

1868 Koloman Josef Moser is born in Vienna on 30 March (as an artist he will call himself "Kolo Moser"). He is the son of Josef Moser, the administrator at the Theresianum, an academy founded by Maria Theresia, and his wife Theresia, née Hirsch. After primary school he attends business school and takes drawing lessons at the Kunstgewerbeschule (School of Applied Arts) without his parents' knowledge. It is his father's wish that upon completing his studies at business school he will start working in a soap and perfume shop on Vienna's Graben – the city's prestige shopping street.

1885 He passes the entrance exam to the Academy of Fine Arts in Vienna. When his father finds out, after some initial hesitation he supports his son's desire to become an artist.

1886–1892 He studies at the Academy of Fine Arts in Vienna under Franz Rumpler, Christian Griepenkerl and Josef Mathias von Trenkwald. His father dies unexpectedly in 1888. Moser is forced to fund his own studies and achieves this by working as an illustrator for magazines and publishers, and soon for clients in Germany as well.

1892/93 He becomes the art teacher to Archduke Carl Ludwig's children at the Villa Wartholz in Reichenau an der Rax.

1892–1897 Seven young artists meet informally but regularly in the Siebenerklub (Club of Seven). This group was admitted into the Künstlerhaus, the Austrian Artists' Society, in 1896, where it became one of the seeds of the Vienna Secession.

1893–1895 Studies at the Kunstgewerbeschule of the Österreichisches Museum für Kunst und Industrie in the painting class taught by Franz Matsch.

1897 On 3 April Kolo Moser becomes a co-founder of the "Union of Austrian Artists, Secession". He wins the competition for designing the vignette for the letterhead and greatly influences the group's publication *Ver Sacrum*, to which he will contribute almost 140 illustrations over the next six years and whose exhibitions he often organises. In the autumn of this year he travels via Munich, Nuremberg and Bamberg to Leipzig, Dresden and Prague.

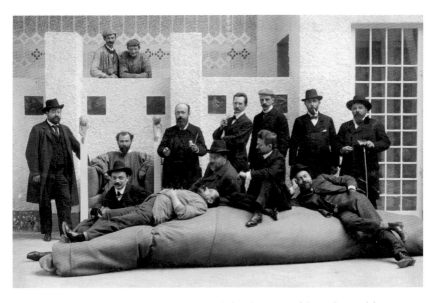

56 Gustav Klimt with members of the Vienna Secession, before the opening of the Beethoven exhibition; Back row, left to right: Anton Stark, Gustav Klimt, Adolf Böhm, Wilhelm List, Maximilian Kurzweil, Leopold Stolba, Rudolf Bacher; Front row, left to right: Kolo Moser, Maximilian Lenz (lying down), Ernst Stöhr, Emil Orlik, Carl Moll, 1902, gelatin silver print

57 Kolo Moser, c. 1900
Private collection, Vienna

1898 In November the Secession Building, built by Joseph Maria Olbrich, opens; as ornamentation for the façade Kolo Moser contributes stylised trees – these no longer exist – and owls as well as the frieze of women wearing wreaths. He is co-organiser of the second Secession exhibition and will produce many textile designs for Johann Backhausen & Söhne company over the next few years.

1899 Kolo Moser starts teaching at the Kunstgewerbeschule of the Österreichisches Museum für Kunst und Industrie in Vienna. He travels to Prague, Dresden and Berlin in the summer and is co-organiser of the third, fourth and fifth Secession exhibitions. In addition he designs the catalogue for the fourth and the poster for the fifth Secession exhibition. He starts creating glass designs for E. Bakalowits Söhne. His "Meteor" glassware set wins the first prize of the Hoftiteltaxfonds.

1900 Kolo Moser is appointed professor for the decorative painting and drawing class at the Kunstgewerbeschule in Vienna, where he will continue to teach for the rest of his life. In April he travels to the World Fair in Paris, where the Austrian contribution concentrates on its arts and crafts, including Kolo Moser's glass designs. He organises the seventh and eighth Secession exhibitions, and delivers designs for Portois & Fix the furniture company and for Josef Böck's porcelain factory in Vienna.

1901 In February he travels to glass factories in Bohemia together with Ludwig Bakalowits. He is a co-organiser of the tenth Secession exhibition and solely responsible for the room design of the twelfth Secession exhibition. He designs a window for the Hotel Bristol in Warsaw, and stage sets, costumes, posters and programmes for the Theater an der Wien in Vienna.

1902 Kolo Moser, his mother and sister move into the house on the Hohe Warte built by Josef Hoffmann; he furnishes it with items he has designed himself. In the summer he travels to Trieste, Venice and Padua. He contributes the room design, the poster and the catalogue for the thirteenth Secession exhibition. Together with Josef Hoffmann he furnishes rooms in the villa belonging to the textile industrialist Fritz Waerndorfer. He will regularly design furniture for the Prag-Rudniker wickerwork factory and the Jacob & Josef Kohn bentwood company over the next few years.

58 Josef Maria Olbrich, an unknown person, Kolo Moser and Gustav Klimt in
Fritz Waerndorfer's garden in Vienna's 18th district, Weimarer Strasse 59, 1902

59 Portrait of Kolo Moser in a hat,
taken by Friedrich Victor Spitzer,
his neighbour on the Hohe Warte, 1904
Private collection, Vienna

60 Editha (Ditha) Moser, 1908
Private collection, Vienna

1903 In May Kolo Moser sets up the Wiener Werkstätte together with Josef Hoffmann and the financier Fritz Waerndorfer. He designs entire interiors but also individual items of furniture as well as various everyday objects made of a wide variety of materials. In June he travels to Switzerland with Carl Moll, where he meets Ferdinand Hodler and Cuno Amiet. The journey continues to France, Belgium and northern Germany. He designs the rooms of the eighteenth Secession exhibition.

1904 The Wiener Werkstätte expands its production; the first exhibition takes place in Berlin in September. Kolo Moser organises it, but continues to be a sought-after sole or co-organiser for the Secession. The Wiener Werkstätte receives many commissions for interiors, including for the sanatorium in Purkersdorf. He develops designs for windows and altars for the Church of St Leopold (Kirche am Steinhof) in Vienna, but only the windows are implemented. The journalist Hermann Bahr nicknames Moser "The Tausendkünstler" ("The Thousand-Artist") on account of his inventiveness as a designer.

1905 Kolo Moser leaves the Secession he helped found along with Gustav Klimt and a group of like-minded artists who lean towards stylisation and are arguing with the "Naturalists". In April he travels to Berlin with Josef Hoffmann to furnish the Stonborough apartment. On 1 July 1905 he marries the industrialist's daughter Editha Mautner von Markhof, who is working as an artist herself; he converts to the Protestant faith for her. The couple move into a flat in the garden wing of the Mautner-Markhof residence in Vienna's third district.

1906 On 21 August Moser's first son Karl is born. Together with Josef Hoffmann he designs the sales room of the Jacob & Josef Kohn bentwood company in Berlin. The postage-stamp series he has designed for Bosnia-Herzegovina is released in November.

1907–1909 Kolo Moser leaves the Wiener Werkstätte because of differences with Fritz Waerndorfer; he focuses more on painting again. In the summer of 1907 he travels to Venice and Padua; in the following year he travels to Venice again, this time with his wife and Hermann Bahr. Because of accusations of plagiarism regarding the altarpiece in the Church of

61 Kolo Moser with his son Karl in the garden of the Mautner Villa in Vienna, c. 1907, Private collection, Vienna

62 Ditha and Kolo Moser, c. 1907
Private collection, Vienna

63 Kolo and Ditha Moser with their children Karl and Dietrich, 1912
Private collection, Vienna

St Leopold, he sues Karl Ederer who had taken over the project from him. In 1908 he designs a series of stamps for the diamond jubilee of Franz Joseph I, Emperor of Austria. In honour of this anniversary Gustav Klimt also organises an art exhibition that allows once again a powerful joint appearance of the Secession founders and "stylised" artists. Kolo Moser designs several rooms in the exhibition. On 1 July 1909 his second son, Dietrich, is born.

1910/11 The 100-krone bank note designed by Kolo Moser goes into circulation. He creates stage designs for operas by Julius Bittner and takes part in exhibitions in Vienna and Rome.

1912/13 Kolo Moser is the designer for several stage plays, and exhibits in Dresden, Vienna, Rome, Düsseldorf and Mannheim. In spring 1913 he takes his son Dietrich to a sanatorium in the Swiss health resort of Leysin. He subsequently meets Ferdinand Hodler in Geneva, who will influence his painting style.

1915/16 He designs Kriegswohltätigkeitsmarken (war-charity stamps) and makes designs for Hermann Bahr's play *Der muntere Seifensieder*. In 1916 he exhibits at the Kunstschau Wien in Berlin. That same year he is diagnosed with incurable carcinoma of the maxillary sinus.

1918 Kolo Moser dies on 18 October. He is buried at Hietzing Cemetery in Vienna. Death tears him away from his rich painting activity of the past few years.

64 Kolo Moser smoking, 1912, Private collection, Vienna

Original design for the first "Ver Sacrum" magazine with the complete layout and print spaces, 1897, pencil, coloured chalk, ink, watercolour on paper 30.7 × 29.5 cm, Leopold Museum, Vienna, inv. no. 1655

ARCHIVE

Selected Designs by Kolo Moser
for the Magazine *Ver Sacrum*
1897–1903

Ver Sacrum (Sacred Spring) was the programmatic magazine of the Secession. No artist contributed to this publication in as varied a manner as Kolo Moser. Be it as a painter, a draughtsman, an applied artist, a fashion designer, a designer of furniture or entire interiors – Kolo Moser was a leading contributor in all areas during these intense formative years of Viennese Modernism. In particular, he also shaped the generations that came after him as a generous teacher and professor. The genius of this prolific artist is demonstrated by the fact that he also helped co-found the Wiener Werkstätte in 1903 and that he always maintained a playful ease despite the commercial responsibilities and multiples pressures he faced.

In addition to shaping (either alone or in co-operation with other artists) twelve of the 23 Secession exhibitions that took place before he left the group in 1905, his most important contribution to the Secession was surely his six-year involvement in the publication of the magazine *Ver Sacrum* (1898–1903). He designed almost 140 drawings – from vignettes, initials, decorative strips and ornamental frames for text to two front and rear covers and many supplements, creating almost everything that made this publication one of the most successful of its day. It was accompanied by an active publication of catalogues that Kolo Moser oversaw while also creating posters for the exhibitions.

It was also probably Kolo Moser who suggested in one of the first meetings of the newly founded Secession the establishment of a publication for the group in the first place, immediately presenting a design for this art magazine with articles on the visual arts, poetry and fiction. The unusual square format of the magazine is quite striking; in this format Moser succeeded in creating a balanced ratio between the picture and text portions. None of the other European art publications of that time showed itself to be so steeped in the notion of the collectivity of all the arts to the extent that its harmonious distribution of the picture, text and ornamental elements turned it into an artwork in its own right. Much as the magazine changed during the time it was in circulation, these principles remained in place throughout the six years.

After *Ver Sacrum* had more than fulfilled its groundbreaking mission and had been celebrated by readers and critics alike, the informational value was put more firmly in the foreground from 1900. Starting in its third year, the magazine was published fortnightly instead of monthly, but the print run was smaller.

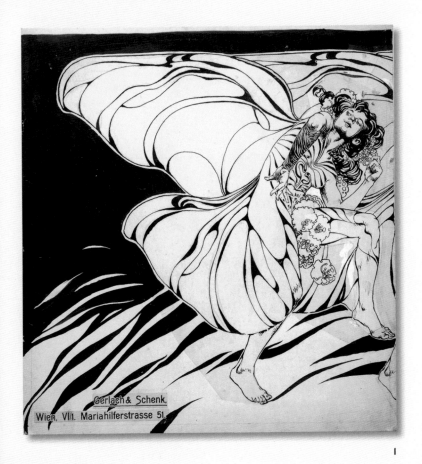

Gerlach & Schenk.
Wien. VI/1. Mariahilferstrasse 51.

1

The *Butterfly Girl* (1) and the *Iris* (2) date from the year 1898; the latter illustrates a poem. Test prints of three woodcuts depicting female dancers (3, 4, 6) date from 1902 and 1903. The sheet November manages to portray the coldness and darkness of this time of year in a particularly well-conceived manner (5). Kolo Moser also designed a girl's head for *Ver Sacrum*

1 *Butterfly Girl for "Ver Sacrum"*, 1898, Indian ink, heightened in white
Paper, board, 44.4 × 41 cm, Leopold Museum, Vienna, inv. no. 5974

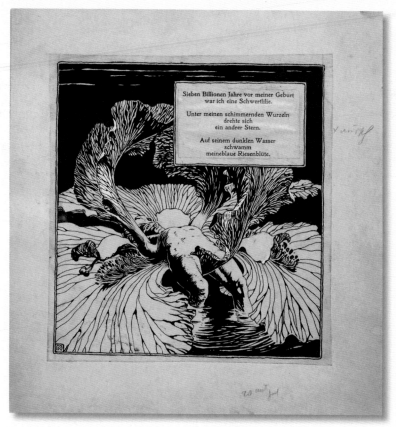

2

that is depicted slightly tilted forward and in profile. These portraits in profile are particularly common in the first year of the magazine. The version depicted here shows the motif as a copper relief (8). Five vignettes for *Ver Sacrum* from the year 1900 round off the depictions in this archive (7).

2 *Iris – Illustration for a poem by Arno Holz, original preparatory drawing for "Ver Sacrum"*, year 1, magazine 11, p. 2, 1898, ink, opaque white 28.1 × 26.3 cm, Leopold Museum, Vienna, inv. no. 5975

3

4

3, 4 *Dancing Girl – Two proofs for "Ver Sacrum"*, 1902, woodcut, purple
or red chalk, watercolour on paper, 18 × 24.5 cm (purple), 21.6 × 23.3 cm
(red), Leopold Museum, Vienna, inv. no. 1664_1 and _2

5

5 *November – Proof for "Ver Sacrum"*, 1902, woodcut, watercolour
on paper, 21.3 × 20.2 cm, Leopold Museum, Vienna, inv. no. 1663

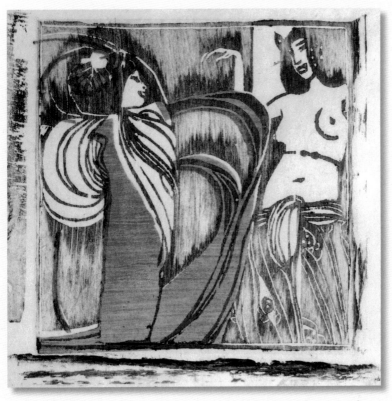

6

6 *Two Dancing Girls – Proof for "Ver Sacrum"*, 1903, woodcut on paper
22.8 × 20.3 cm, Leopold Museum, Vienna, inv. no. 1662

7

7 *Five vignettes for "Ver Sacrum"*, c. 1900, 2 woodcuts, 3 originals
in Indian ink, 22 × 20.5 cm, Leopold Museum, Vienna, inv. no. 2681

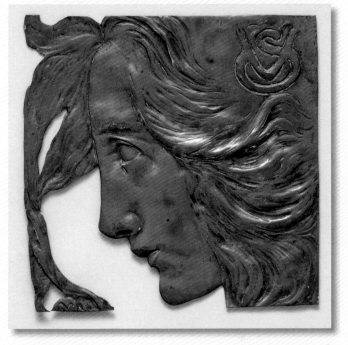

8

8 *Girl's Head for "Ver Sacrum"*, 1900, copper, 9.5 × 9.6 cm
Leopold Museum, Vienna, inv. no. 6037

SOURCES

EXCERPTS WERE TAKEN FROM THE FOLLOWING LITERARY SOURCES:

Interview by Gerd Pichler with Rudolf Leopold, in: exh. cat. *Koloman Moser, 1868–1918*, Prestel Verlag, Munich 2007.

Published by
Hirmer Verlag GmbH
Nymphenburger Strasse 84
80636 Munich
Germany

Cover illustration: *Lovers* (detail), c. 1914,
see page 54
Double page 2/3: Lake *Wolfgang with Turbulent
Water* (detail), c. 1913, oil on canvas,
dimensions with frame: 59.6 × 59.6 × 4.6 cm,
Leopold Private Collection
Double page 4/5: *Poster design for the "ERSTE
GROSSE KUNSTAUSSTELLUNG" of the Secession*
(detail), 1897, see page 17

www.hirmerpublishers.com

This book is published to accompany the exhi-
bition *Kolo Moser. The Leopold Collection* in the
Leopold Museum, Vienna, 18 January – 10 June
2018.

The authors and the publisher would like to
thank Daniela Kumhala for the co-ordination
with the Leopold Museum.

—
TRANSLATION
Michael Scuffil, Leverkusen
Josephine Cordero Sapién, Exeter

—
COPY-EDITING/PROOFREADING
Jane Michael, Munich

—
PROJECT MANAGEMENT
Gabriele Ebbecke, Munich

—
DESIGN/TYPESETTING
Marion Blomeyer, Rainald Schwarz, Munich

—
PRE-PRESS/REPRO
Reproline mediateam GmbH, Munich

—
PAPER
LuxoArt samt new

—
PRINTING/BINDING
Passavia Druckservice GmbH & Co. KG, Passau

Bibliographic information published by the
Deutsche Nationalbibliothek
The Deutsche Nationalbibliothek lists this
publication in the Deutsche Nationalbibliografie;
detailed bibliographic data are available on the
Internet at http://dnb.dnb.de.

ISBN 978-3-7774-3072-0
Printed in Germany

———●———

THE GREAT MASTERS OF ART SERIES

ALREADY PUBLISHED

WILLEM DE KOONING
978-3-7774-3073-7

EMIL NOLDE
978-3-7774-2774-4

PAUL GAUGUIN
978-3-7774-2854-3

PABLO PICASSO
978-3-7774-2757-7

RICHARD GERSTL
978-3-7774-2622-8

EGON SCHIELE
978-3-7774-2852-9

VASILY KANDINSKY
978-3-7774-2759-1

VINCENT VAN GOGH
978-3-7774-2758-4

HENRI MATISSE
978-3-7774-2848-2

www.hirmerpublishers.com